The Soul of Art

Alfred J. Garrotto

The Soul of Art

Copyright © 2016 by Alfred J. Garrotto

All rights reserved. No part of this book may be reproduced or transmitted in any form or by any means, electronic or mechanical, including photocopying, recording, or by any information storage or retrieval system, without the permission of the Author, except where permitted by law.

First Edition

ISBN-13: 978-1537726410

ISBN-10: 1537726412

CreateSpace, Charleston, South Carolina, USA

Cover Image, "On Dancing Light
© 2016 by Douglas MacWilliams Lawson
Used with permission. All rights reserved

2016

Also by Alfred J. Garrotto

Fiction

There's More: A Novella of Life and Afterlife

The Saint of Florenville: A Love Story

I'll Paint a Sun

Circles of Stone

Down a Narrow Alley

Finding Isabella

A Love Forbidden

Nonfiction

*The Wisdom of Les Miserables:
Lessons From the Heart of Jean Valjean*

Screenplays

There's More

The Saint of Florenville: A Love Story

The Terrorist's Daughter
(adaptation of *Down a Narrow Alley*)

As a professional ballet dancer, you had better not bump into anyone. As a performer and choreographer in this art, I take this to be a personal fact. So why did my ophthalmologist tell me that my eyesight needed attention? What about my "night vision" that checks out at 20/20? In this book, Alfred J. Garrotto defines "night vision" as the ability of the artist to imagine and visualize the gift of creativity.

The wisdom and guidance in The Soul of Art *motivates artists to "never give up," but rather to seek ever higher goals in their art form, knowing always that what we have is God-given and a privilege.*

Artistic Director, choreographer and Premier Dancer Andrei (Bill) Tremaine – soloist, Ballet Russe de Monte Carlo, and founder of The Pacific Ballet Theatre.

In memory of my dear friend

Sue Aggetta
(1939-2016)

Artist — Poet — Dancer — Photographer

Table of Contents

Acknowledgments	1
Foreword	3
Part I — Imagine!	5
Part II — Truth in Art	47
Part II — I Am . . .	71
Part IV — Sharing Our Gifts	89
Afterword	111

Acknowledgments

In the late 1930s, my dad Joe Garrotto was a night janitor at the famed MGM Studios in Culver City, California. Studio photographers practiced their lighting techniques on him (what were they doing there in the middle of the night?). As a child I treasured those black-and-white images that made him look like a real movie star. It was during this period that Dad got the film bug and wrote a screenplay that I still have in my possession. Unfortunately, it never made it to the big screen. As far as I know, he never wrote for publication again. Along the way, he must have passed some bits of writing DNA to me, along with whatever talent I may have in that area of the arts. Thanks, Pop.

I am grateful also to Father Brian Joyce, pastor emeritus of Christ the King Parish, Pleasant Hill, CA. One early summer day in 2016, we crossed paths in the parish office. I told him I was writing a book for creative people engaged in the arts. He said, "Only the artist can see in the dark."

Later, I thought, "Wow! That's what my book is about." I searched the Internet for those exact

words in hope of finding their source. Nothing. The next time I saw Brian, I asked whom he had quoted. He looked puzzled. Apparently, it had come out spontaneously! Truth be said, he didn't recall saying it. I believe in divine, on-the-spot— but not "on demand"—communications.

I owe so much to my "homies" in the Mt. Diablo Branch of the California Writers Club. Not because I've neglected to pay my annual dues. No, I'm indebted, because they've honored and nurtured my gifts. Above all, they show me what it means to be a professional writer, as well as what it takes to believe in myself and stay positive in today's ultra-competitive publishing market. Simply, they model the *joy* of the writing life.

I'm also grateful to Franciscan Brother Michael Minton, OFM, Director of San Damiano Retreat in Danville, CA, and to his staff for giving me an opportunity to present my Art & Soul concepts in a one-day retreat format.

To Douglas MacWilliams Lawson for allowing me to use "On Dancing Light" for my cover art.

And to my wife Esther. Mere human words are inadequate to express my love and gratitude.

Foreword

I completed the second of many drafts of this book while vacationing in Princeville, on the island of Kauai, Hawaii. On an alternately sunny-drizzly Saturday afternoon, we strolled peaceful Hanalei Beach viewing entries in a sandcastle contest. Though constructed mostly by families, not professionals, each entry showed imagination and artistic ability.

We saw mermaids shaped breast-to-tail fins around live young women, who seemed not to mind being admired while encased in damp sand. Other sand sculptors shaped miniature locomotives. Another formed a realistic tribute, featuring surfboards, with Olympic rings on one side and a big Aloha+2016 on the other. With the Rio Games running at the same time, this became a popular photo stop.

The event reminded me of an inspiring quote by author Shannon Hale that sustained me through each subsequent draft:

I'm writing a draft and reminding myself that I'm simply shoveling sand into a box so that later I can build castles.

I'll let you decide if this little book—a shovel full of words like grains of sand—has become a castle. It sure has been fun bringing it into being. The concept originated as a one-day retreat/workshop on the spirituality of the arts. Its launch at San Damiano Retreat in Danville, CA, was so well received that converting and expanding the material seemed an inevitable next step. In sharing these convictions in book form, I hope to reach an even wider audience.

While my primary focus is on the widespread community of writers, composers, dancers, musicians, actors, etc., I am aware that creative people in many fields give expression to imaginative ideas. I'm thinking about inventors of all types, men and women who design the products we use every day—and take for granted—and all other creative folks, who do not call themselves artists, but whose ingenuity enhances the lives of countless people. While they are not my primary audience, I pay homage to them for their contribution to the betterment of our world.

Part I

Imagine!

Seeing in the Dark

Only the artist can see in the dark.

Brian T. Joyce

Night-vision is a gift bestowed upon every artist. Among all humanity, the artist best comprehends the difference between "seeing" and "perceiving." Every sighted human can see, but there is a darkness, a blindness in the human spirit, that has little to do with the ability of the brain to communicate electronically with our optical nerves.

Jesus of Nazareth knew this better than anyone. That's why he taught primarily through the medium of story, referred to as "parable." In doing so, he bypassed—but did not dismiss—the truth of facts and history and science.

In a passage from the Gospel of Matthew (13:10-17), he explained the dynamic of seeing in the dark.

> *[Jesus'] disciples came to him with the question, "Why do you speak in parables?"*

Jesus answered, "To you it has been given to know the secrets of the kingdom of heaven, but not to these people. For the one who has, will be given more and he will have it in abundance.

"But the one who does not have will be deprived of even what he has. That is why I speak to them in parables, because they look and do not see; they hear, but they do not listen or understand. In them the words of the prophet Isaiah are fulfilled:

'Much as you hear, you do not understand; much as you see, you do not perceive. For the heart of this people has grown dull. Their ears hardly hear and their eyes dare not see. If they were to see with their eyes, hear with their ears and understand with their heart, they would turn back and I would heal them.

'But blessed are your eyes because they see, and your ears, because they hear. For I tell you that many prophets and upright people would have longed to see the things you see, but they did not, and to hear the things you hear, but they did not hear it.'"

In his book, *Thank God For Evolution*, theologian and evolutionary cosmologist Michael Dowd offers this explanation (paraphrased): Night experience (the truth of mystery) communicates with us through *night language,* by way of grand metaphors, poetry, and vibrant images.

Our attention focuses on: What does it mean? The amazing power of the Arts is the ability to bridge the artificial, self-constructed divide between the realms of spirit and flesh and give us access to both sides of reality.

Night language is the language of myth, fiction, dance, music, poetry, art, dreams, and storytelling. It plunges us into that deepest of all mysteries— human nature and the nature of our Creator-Spirit.

Throughout this book, I use Creator-Spirit to refer to the divine source of all artistic gifts and creative expression. "Creator" speaks to the outward manifestation of art. The first act of creation, the first material expression of art, was what today we call the "Big Bang."

"Spirit" reminds us that, in all realms of existence, we are immersed in an indescribable mystery. We

need a kind of vision beyond the capacity and function of our physical eyes to penetrate the why" of the universe—and our place in it.

Imagination: Source of Our Gifts

All art is conceived in the womb of imagination. Listen to Albert Einstein:

> *Logic will get you from A to Z.*
> *Imagination will get you everywhere.*

True artists recognize that they are not the source of their gift, but receivers. Like a great sower, Creator-Spirit showers every society with people having special gifts of raising their communities beyond the material limitations of day language. Almost all Christian and other sacred writings (scriptures) are expressed in night language. Why? Because night language plunges us into the two deepest mysteries of all: human nature and the nature of Creator-Spirit.

> *People who think poetry has no power have a very limited conception of what power means And this is why poetry is so*

> *powerful, and so integral to any unified spiritual life: it preserves both aspects of spiritual experience, because to name is to praise and lose in one instant. So many ways of saying God.*
>
> Christian Wiman, *My Bright Abyss: Meditation of a Modern Believer*

Dowd reminds us that this side of our experience deals in *subjective* reality, as contained in nighttime dreams. What we dream contains truth both for us and about us—our feelings about life, our fears, what makes us happy and what fuels our darker instincts. "Though it is not *objectively* real," he writes, "night language is personally or culturally meaningful. It nourishes us with spectacular images of emotional truth."

A problem with night language is that, too often, we just don't get it. Many of us look at a work of fine art and see only paint on canvas (or other medium). We listen to a song and hear only notes and words. We read an insightful novel or poem and fail to grasp the author's story within the story or the penetrating, but out-of-view, truth concealed

between the lines. The same can be said for contemporary and classical music—from the back hills of Kentucky to La Scala Opera House in Milan, Italy.

Night Language in the Hebrew Scriptures

The prophet Ezekiel (1:2-28) gives us a great example of night language as our primary access to the invisible, otherwise inaccessible divinity:

> *The hand of Yahweh was upon me.*
> *I looked: a windstorm came from the north bringing a great cloud. A fiery light inside it lit up all around it, while at the center there was something <u>like</u> a glowing metal. In the center were what appeared to be four creatures with the same form. . . . The surrounding light <u>was like</u> a rainbow in the clouds after a day of rain. The vision <u>was</u> <u>the likeness</u> of Yahweh's glory.*

Notice the use of similes, "like," "was <u>like</u>" and "was the <u>likeness</u> of." We are incapable of seeing Creator-Spirit's full reality. All we have is a trail of breadcrumbs along our path.

Jesus, the Great Story Teller

Jesus used succinct stories to teach about the nature of God (*abba,* "*Daddy*"). Like everyone before him, human words and symbols and local manner of speech (in his case, the Aramaic dialect of Hebrew) restrained him. With characteristic wisdom and insight, Christian Wiman probes the reason why Jesus chose story as his primary literary vehicle for sharing his "Good News" with those who would listen:

> *Christ speaks in stories as a way of preparing his followers to stake their lives on a story, because existence is not a puzzle to be solved, but a narrative to be inherited and undergone and transformed person by person.*

The most widely read storyteller in the history of the world had to do a most unthinkable deed, dreaded by every artist—stop to parse point by point the meaning of his story.

One such example appears in the Gospel of Matthew (13:36-41). His closest followers were there, and he had just told his listeners this parable.

> *The kingdom of heaven can be compared to a man who sowed good seed in his field. While everyone was asleep, his enemy came and sowed weeds among the wheat and left.*
>
> *When the plants sprouted and produced grain, the weeds also appeared. Then the servants of the owner came to him and said: "Sir, was it not good seed that you sowed in your field? Where did the weeds come from?"*
>
> *He answered them: "This is the work of an enemy." They asked him: "Do you want us to go and pull up the weeds?"*
>
> *He told them: "No, when you pull up the weeds, you might uproot the wheat with them. Let them just grow together until harvest; and at harvest time I will say to the workers: Pull up the weeds first, tie them in bundles and burn them; then gather the wheat into my barn."*

Clearly, Jesus' disciples didn't get it, any more than most of the people in the crowd. They heard and understood the words coming out of the rabbi's mouth, but they were still too earthbound for those words to reach inside them to the deepest reaches of their spirit. To their credit, they had the humility to admit their ignorance.

> *His disciples came to him saying, "Explain to us the parable of the weeds in the field." Jesus answered them, "The one who sows the good seed is the Son of Man. The field is the world; the good seed are the people of the Kingdom; the weeds are those who follow the evil one. The enemy who sows them is the devil; the harvest is the end of time and the workers are the angels. Just as the weeds are pulled up and burned in the fire, so will it be at the end of time. The Son of Man will send his angels, and they will weed out of his kingdom all that is scandalous and all who do evil."*

℘

This book celebrates artists and poets and songwriters, composers and singers, playwrights and actors who "see in the dark" in order to help the rest of us see. Often, they read the "signs of the times" long before anyone else catches on. Their mission is to shine a light on truths that are just beyond the reach of those who spend their waking hours bogged in the muddy trenches of everyday life and its immediate demands.

Together, we will explore the intimate relationship between artists and Creator-Spirit (use your own chosen term for eternal wisdom). We in the arts are entrusted at birth with the ability to see and share what most other people cannot comprehend, but must, if they hope to find meaning, wholeness, and true love during their time on earth.

> *I believe in visionary feeling and experience, and in the capacity of art to realize those things. I also believe that visionary art is a higher achievement than art that merely concerns itself with the world that is right in front of us.*
> Poet and author Christian Wiman,
> *My Bright Abyss*

What Does It Mean to "Create"?

All civilizations, prehistoric to the present, have felt the need for a creation story. This arises from a fundamental human need to explain where we came from, how we got here in the first place. And, what it's all about (Alfie)?

In the Hebrew Scriptures, out of which Christianity blossomed, the creation story begins in the first line of the first chapter, of the first book—"In the beginning..." (Genesis 1:1).

Beginning? Already, we're caught up in the imagery of story/poetry to explain the unexplainable. *Some*-thing from *no*-thing? What might this mean in *human* terms? As artists, we identify ourselves as "creative" people. What do we mean? Can we legitimately claim the title, "creators"?

Let's see, beginning with this statement by Charles Desmarais, *San Francisco Chronicle* art critic, in his article, "Waters remodels our home" (April 16, 2016). The world of art is:

> *. . . an alternate realm, artificial by design. It is the place we have made out of objects we had to create, because they did not exist. [It is] the world we wish we had been given.*

Following Desmarais's lead, as human artists—whatever the realm of our gifts—we:

- bring into being (create from 'nothing that existed like it before');

- objects *we* had to make (because no one else could do it in exactly the same way).

> *"The desire to create is one of the deepest yearnings of the human soul."*
>
> Dieter F. Uchtdorf

Using our gifts and talents (*charisma*, in Greek), we give life to a world we *wish* we had received at birth but didn't, simply because that raw material has been waiting for us to produce it with our own unique gifts.

In the words of Y. B. Yeats:

> *The world is full of magic things, patiently waiting for our senses to grow sharper.*

What is "Art"?

Art covers a wide and diverse range of human <u>ac</u>tivities. The word 'act' immerses us in the concept of *outward expression* of our gifts and talents.

Art is a noun. In its most profound sense, it's a verb—in the same way that 'love' is a verb. Art isn't *really* art until it's given away (expressed in some human way). Anyone hear musical echoes from *Sound of Music*? Richard Rodgers and Oscar Hammerstein expressed this simply and beautifully:

> *A bell is no bell till you ring it, a song is no song till you sing it, and love isn't love till you give it away.*

Creative gifts are seeds (remember Jesus' parable?) scattered among the human race and planted in the soul of every artist, primarily for the good of others. That doesn't mean we can't enjoy our gifts and use them for our own joy and entertainment.

But in the arts, Self is secondary. It yields to the good of the Other, just as Creator-Spirit willed to manifest the beauty divine presence in every corner of the Universe and in the spirit of every human being on Earth.

> *Every artist dips his brush in his soul and paints his own nature into pictures.*
>
> Henry Ward Beecher

Imagination: Mother of Art

A true artist is humble enough to recognize that he or she is the receiver of the gift, not the source. Where does art come from? Who is its mother? Francisco de Goya (1746-1828), that Spanish master, answers this question in a line that could have been spoken by any creative person:

> *United with reason, imagination is the mother of all art and the source of all its beauty.*

So, the mother of art is our human ability to imagine. Imagination is our "wild" faculty, the one for whom limits are nonexistent.

The Soul of Art

The *father* of art is human reason. Without the tempering hand of sound reasoning and clear discernment, art and the artist risk self-destruction. Examples abound in the history of art, and we'll discuss this later in the book.

Imagination. What a gift! It was none other than Albert Einstein who said:

> *Logic will get you from A to Z.*
> *Imagination will get you everywhere.*

It allows us to participate in Creator-Spirit's life-giving work. What would life be like without the ability to imagine—to see possibilities, dream dreams, envision an unknown future, and know by non-physical instinct the innermost spirit of another person. Pablo Picasso put this concept more succinctly than I can:

> *Everything you can imagine is real.*

These words of one of the most innovative painters of our—or any—time feed into a theory I subscribe to. It goes like this: every character an author creates or a painter puts brush to (or other instrument that transfers internal images to a

physical surface, including digital) continues to exist in a parallel universe. Yes, we generate life in these our "children." And, like us, they will never cease to exist! Which of us, whether author, playwright, screenwriter, or any creator of fictional characters has not felt that in our bones? What universe do they inhabit? We may find out someday—or we may have to hold them in our hearts forever.

Creator-Spirit, the great sower, showers every society with people—artists—having special gifts of raising their communities beyond the limits of day language.

The late Fr. Andrew Greeley's book, *The Catholic Imagination,* described how essential this faculty is to Roman Catholics and other sacramental churches.

> *Catholics live in an enchanted world . . . of statues and holy water, stained glass . . . saints and religious medals, rosary beads and holy pictures Catholics see the Holy lurking in creation We find our houses and world haunted by a sense that the objects, events, and persons of daily life are revelations of [God's] grace.*

Sadly, we live in a world often devoid of such imagination. The result is widespread feelings of helplessness, hopelessness, and despair. No one should blame another for crying out:

> *Someone tell me, please, that there's more to life than this!*

Artistic imagination fills that void, showering us and our planet with wonder and hope. Artists' message to our audiences is, "There's more" . . . more than what we see and feel, more than the sum of our daily anxieties and fears.

To communicate this "more" message to a world without hope and therefore no foreseeable future, artists need to learn the language of compassion.

The compassionate artist accompanies people on their journeys and invites them to share the journey of vision and hope. Without artists and our ability to "suffer with" the plight of our fellow humans, imagination goes off the track. In the words of that great man of science, Albert Einstein:

Compassionate people are geniuses in the art of living, more necessary to the dignity, security, and joy of humanity than the discoverers of knowledge.

Other Examples of "Night" Language

Simile

John Denver was a master of lyrical metaphor. In "Annie's Song," he plays on our heartstrings with a quintet of similes we easily recognize, whether we've experienced them personally or seen them in films or the media.

The object of his love fills up his senses, <u>like</u> "a night in a forest" . . . <u>like</u> a "mountain in springtime" . . . <u>like</u> "a walk in the rain" . . . <u>like</u> a storm sweeping across a desert. Like the comforting sight and sound of "a sleepy blue ocean."

We are filled but never sated with these expressions of the tenderness of "night language" love.

Story, Fable, Parable

Storytelling is an art form plied by every artist, regardless of genre. We in the arts live in the world of story. It's the only medium capable of expres-sing the visions we see and are driven to share with anyone who will pause long enough to listen or observe.

Jesus of Nazareth was a great storyteller, for some the greatest ever. In the Catholic Pastoral Bible, a contemporary English version, a frequent opening line of his more than fifty short stories (parables) is: "Can you imagine?" Also, "This story throws light on...."

Having awakened his listeners' inner senses, Jesus proceeded with... "Our God is *like* a ___(woman, king, father of two sons, farmer, pearl merchant, etc.) ___, who...."

Why did Jesus use similes and metaphors when witnessing to the nature of the invisible Creator-Spirit? Why not open the heavens and let people see God with their own physical eyes? Wouldn't it be a whole lot easier to accept the message, then?

Answer: There is nothing for our eyes to "see," even if the heavens "opened up" for our inspection. Physical vision's limit is the material universe. The science of physical sight requires an external object the brain can process into three-dimensional images.

Human imagination is not so limited. It has a greater capacity for sight than our eyes do. As poet Christian Wiman puts this, *My Bright Abyss*, imagination unlocks the mystery of the physical world.

> [Jesus] uses metaphors because something essential about the nature of reality—its mercurial solidity, its mathematical mystery and sacred plainness—is disclosed within them.

What I hear Wiman saying is that imaginative language enhances our physical ability to see and understand the deeper truth of the material world.

Playwrights, screenwriters, novelists—songwriters and poets perhaps most of all—invite their audiences: "Come with me on a journey. Free your imagination, and I will take you somewhere your

inmost spirit has never been before. And in the end, you'll see the physical world around you more clearly than ever."

Music, story, images— in all genres of the arts— draw us deeper and deeper into the physical and moral reality of our lives. Whether we are the actor or the audience, art pierces the armor of our ego and defense mechanisms, exposing us to the reality of our selves—ever so briefly, sadly all too briefly. In a real sense we can say that, unless we fight it mightily, art forces us into the fourth of the twelve steps of recovery in Alcoholics Anonymous, self-knowledge:

> *Make a searching and fearless moral inventory of yourself.*

The artist helps us to verify the saying, "We have met the enemy, and he is *us.*" Where did that quote come from? An artist. And that's another story. Cartoonist Walt Kelly (d. 1973), the creator of Pogo, used that line on a poster he drew for Earth Day, April 22, 1970. Kelly's now famous words are a distortion of the original words of American Navy Commodore Oliver Hazard Perry.

On September 10, 1813, during the War of 1812, his American ships defeated a British squadron on Lake Erie. Perry's words were: "We have met the enemy and they are *ours.*" Kelly's less triumphant version has outlasted the great seaman's.

Day Language

Michael Dowd identifies the other manifestation, or side, of human communication as "day language":

> ... *the language of science, Western medicine, mathematical fact, historical proof, business, technology.... It expresses "what is," primarily in a material, physical sense.*

Day language cannot express the ultimate meaning, the "*why*" of the universe, or the "*why*" of human body-spirit existence.

> Employing the language of night, artists offer insight and otherworldly vision to those of us whose daily lives are steeped in carrying out responsi-

bilities related to the demands that others impose upon us. And those burdens we impose upon ourselves, like going to work, providing for our families, paying taxes, saving for an uncertain future in a volatile investment market, etc.

> *[Jesus] speaks the language of reality — speaks in terms of the physical world — because he is reality's culmination and key (one of them, at any rate), and because "this people's mind has become dull; they have stopped their ears and shut their eyes. Otherwise, their eyes might see, their ears hear, and their mind understand, and then they might turn to me, and I would heal them."*
>
> Christian Wiman, *My Bright Abyss*, (quoting Matthew 13)

Artists span both worlds. These masters of imagination and gifted practitioners of night vision are not exempt from day language burdens. Our hearts cry out for us to hone and share the fruit of our talents, but we have to make a living,

as well. Few us can support ourselves solely by applying our craft.

We tend to focus on success stories, the achievements of famous actors, artists, singers, etc. In doing so, we suffer the temptation to judge ourselves and our gifts negatively by comparison. We forget that the rich and famous among us must still immerse themselves in "day" matters.

> *The language of the Dream/Night is contrary to that of Waking/Day. It is a language of images and sensations, the various dialects of which are far less different from each other, than the various Day-Languages of Nations."*
>
> Samuel Taylor Coleridge

The blessing for those of us in the arts is that—rich or poor, recognized or not—we never lose that inner desire, that vocational call to escape back from our day-life into the realm of night, where we feel at home and are best able to be our true selves.

The Art of Dreaming

If imagination is the mother art, its sister is the ability to dream. This phenomenon takes two forms: night dreaming and day dreaming.

Critical to the artist's growth is the need to (1) remember our night dreams and (2) learn how to interpret them. During sleep, creativity roams free among the multiple universes—physical and spiritual. During our sleep, Creator-Spirit has total access to our unguarded consciousness. This is when our creative spirits regenerate. Many people claim not to dream. In reality, experts on the subject teach us that everyone dreams. Not all of us recall our dreams. As artists, we cannot afford to cut ourselves off from this flow of spiritual energy and inspiration. If we ignore our dreams, our art surely suffers. In what ways this impacts our art, we might never know. Perhaps, in a dream state, a writer is handed the gift of "the great American novel"—and misses the opportunity.

One of our most accessible moments of openness is in the earliest stage of waking, when the veil

dividing spirit from matter is thinnest. We are no longer fully asleep, but not quite awake. A must for every artist is to keep a notepad or one of those bound books of blank pages on our bedside table. Don't forget a pen, of course. I find that my most creative ideas come to me in those earliest hours of morning.

My most notable example occurred several years ago. I awakened to a novel that cried out to be written. On the spot, I had the arc of the story and the main characters handed to me on the proverbial silver platter. The following is from my journal entry of July 26, 2010, written minutes after waking up:

> *Just got an idea for a novel, Train to Bruges. It tells the story of a young Belgian nun and an American priest who spend a weekend touring Bruges and Antwerp, Belgium.*

Over the next few days, details awaited me in half-awake, half-asleep moment. I recorded them in my journal, amplifying my previous notes. It took me a whole year to fill in all the blanks, draft after grinding draft. The result was my sixth novel finally titled, *The Saint of Florenville: A Love Story.*

Here's another true story, one intimately related to a masterpiece of architecture, but it wasn't the architect who had the dream in question.

In the late 19th century, architect Antoni Gaudi (d. 1926) craved the contract to design and build the new basilica of La Sagrada Familia (The Holy Family) in Barcelona, Spain. The rap against him was "too young," "too inexperienced for the task." During the search for the right man—sorry, no women architects in those days—the Archbishop had a dream in which he was "told" that Gaudi was the one. My purpose in including this vignette is to highlight the importance and the sometimes surprising value of being in touch with our dreams.

Day Dreaming

The whole fascinating history of the design and construction of that magnificent (still unfinished) structure is beyond retelling here.

Artists are born dreamers. In our day dreams, we create a future that is not yet. That's part of seeing

in the dark. Few writers begin a novel without dreaming of seeing it on the *New York Times* list of best sellers. Every young thespian or dancer onstage when the curtain opens—be it a school play or local theater production—dreams of a career on Broadway or making it big in Hollywood.

In a way, aren't we closet Walter Mittys, envisioning long and profitable careers in the arts. Artists without day dreams may never reach the full potential of their gift. And what a pity that would be, for everyone.

Who are Human Beings . . . Really?

Who is Creator-Spirit . . . Really?

In *The Restless Heart* Fr. Ronald Rolheiser, OMI, shares an old legend that captures the essence of night language.

> *It is said that, before being born, each soul is kissed by God. Then it goes through life always, <u>in some dark way</u>, remembering that kiss. The soul measures every*

experience in relation to that original sweetness To be in touch with your heart is to be in touch with this primordial kiss, both its preciousness and its meaning.

That's a big Wow!

Who are we? What place do you and I have in this imagination-starved 21st Century world? Answer: We are night language people living in a day language world.

What Does Creator-Spirit Expect of Artists Who Must Straddle Both Worlds?

Let me focus on three areas of divine expectation:

1. That we discover, acknowledge, and hone our craft, so we can seriously, but joyfully, accept our preordained mission in life.

What is that mission? To peer into the mysteries of life surrounding us. Then, to give expression to what we see, with all the joys and blessings that come from that gift of imaginative sight. Our talents are *pure gift*, freely given. I can't state this

any more beautifully than Natasha Middleton, Artistic Director of Pacific Ballet Dance Theatre, based in Burbank, California.

> *Woke up and went to the beach this morn. Message to all us Creatives out there. Just CREATE! Love! Feel! Enjoy! Like I enjoyed my walk with all that God created! Love you, my artist friends and family! Just BE!*

Creator-Spirit has taken a great risk in allowing us free will and autonomous decision making. In bestowing our gift, the risk is that we may never develop and share it to the full extent of our capacity. Creator-Spirit assumes the ultimate risk that we may choose to neglect or even abuse our artistic talent.

I'm reminded of Jesus' parable about the king and his stewards (Matthew 25:14-30). One of the stewards received his portion of the master's fortune, but got cold feet about investing it. His boss returned and demanded an accounting. The report didn't please him: "I was afraid, so I hid your money in the ground. It's all right here, every shekel of it."

We have done nothing to deserve our gifts, but that doesn't mean they come to us with no strings at-tached. Creator-Spirit expects us to cultivate what has been given and use them to make the world a better place for all to live in, by sharing our treasure with an open heart, giving joyfully for the enhancement of our audiences' lives.

In the discovery and assessment of our gifts, we need the virtue of humility. What does that mean? It's admitting the *truth* about ourselves, our gift, and the source of whatever talent we have. We are humble, when we recognize our true place in the divine plan for the Universe. We are humble, when we live out our personal and professional lives in fidelity to that truth.

2. That we make a personal commitment to *passionate* expression—sharing—of our gifts.

It seems strange to raise artistic passion as a question, when speaking of creative people. Yet, it needs to be raised. We all know talented people whose lack of passion for their craft stunts their ability to share their gifts with generous hearts, minds, and bodies. We'll return to this question of artistic passion in Part II, Truth in Art.

3. That we see our career, whether it brings fame or anonymity, as a road to self-discovery and meaning in our own lives.

The way is cobbled and rough at times. And it ends only in when we die. As artistic people, we are at our best when using our Spirit-given gifts to fill in—one unique piece at a time—the puzzle that is Life.

When Does Art Become "Art"?

At what point in the creative process does a work of art earn that name? In other words, does the creative spark—or conception (an apt term) of a piece—constitute art? Or must we see the finished product—a manuscript, a finished composition, a choreographed ballet—before awarding the title, artistic creation?

A partial, real-world answer may be found in New York's Metropolitan Museum of Art exhibit: *Unfinished: Thoughts Left Visible.* This 2016 exhibit in The Met Breuer examined a subject critical to artistic practice: When is a work of art finished? The exhibit consisted of over 170 unfinished works dating from the Renaissance to the present. Are

sketches and never-completed paintings worthy of the title, art? The Met curators think so. I believe the broad world of the arts can accommodate this concept.

Most novelists have half-a-manuscript lying around. In the process of writing *There's More: A Novella of Life and Afterlife*, I had the experience of working on two different novels at the same time. One featured a major league ballplayer, a pitcher named Jack Thorne. The other was a novelization of Victor Hugo's catalyst *Les Miserables* character, Bishop Charles Francois Myriel. In each case, I got to the middle of the story and hit a wall. I saw no way forward. Then, an inspiration!

What if I were to introduce Jack and the bishop to each other? Just to see what happened. I arranged that meeting and guess what? They hit it off right away, and my novella was born. Jack is mortally injured during a World Series game, and Myriel is the guide sent to accompany him through the passageway from life to afterlife. In the process, they grow to like and respect each other, so much so that Jack is reluctant to leave his companion once they must separate at the door to eternity.

Reflections on Part I — Imagine!

There's a lot to reflect on in this first section of the book. The following pages contain reflection questions and space to begin some journaling. The benefit of doing this now rather than later is to record the thoughts that have surfaced during your reading, while they are still fresh.

*In what way(s) do my gifts and talents call me—
and allow me—to see in the dark?*

How do I experience night vision (seeing in the dark) in the expression of my art?

What does Creator-Spirit want FOR me as an artist?

Part II

Truth in Art

Imperfect people are all God has ever had to work with. That must be terribly frustrating But [God] deals with it. So should we!

**Jeffrey Roy Holland
Educator and Religious Leader**

What Does Creator-Spirit Want FROM Me?

In Part 1, Imagine, we gained a better understanding of our creative gifts and their source. They are neither *from* us, nor are they simply *for* us. It's time now to comprehend our responsibility as artists to help others gain deeper human and spiritual insight into the true meaning of their lives.

We might think this task falls under the heading of "religion" and theological tenets and guides. Not so. Art goes beyond what most of us think of, when we use the official language of religion to "explain" the divine. According to Christian Wiman:

> *Art is so often better at theology than theology is.*

The Relationship of Art and Truth

Let's begin with a quotation from John Ruskin, the leading art critic of his time (1819-1900):

Art is not a study of positive reality; it is the seeking for ideal truth.

But, here's the problem—always has been, always will be. After 2,000 years, Pontius Pilate's cynical question still hangs over humanity.

What is truth?
John 18:38

The first writers chiseled intelligible indentations on stone. The first graphic artists made transferable color and applied it with primitive brushes to keep pictorial records of "modern life." Creative people like us today parse and mine this five letter word, t-r-u-t-h, for its elusive meanings.

So, what is truth? I like Pope Francis' definition:

> *Truth is a <u>relationship</u>. As such, each one of us <u>receives</u> the truth and <u>expresses</u> it from within, according to <u>one's own</u> <u>circumstances</u>, <u>culture</u>, and <u>situation</u> in life* [underlines mine].

I've had to read the pope's statement over a number of times. Each word is packed with meaning:

- *relationship*: Truth is a "we," not an "I" concept. Art is a portrayal of truth, so it too must be outgoing, not narcissistic.

- *receives*: Truth implies a giver and someone on the receiving end of the gift.

- *expresses*: Truth invites—no, it demands—a response of generous action.

- *one's own*: Truth is whole. It simply *is*. But, it allows different and unique means of transmission and reception.

- *circumstances*: No two people live identical lives, not even within the most intimate relationships.

- *culture*: Race, ethnicity, place of origin, language, gender, sexual orientation: each self-identifying

factor influences the truth of a message.

- *situation in life*: Economical condition, social status, past and current life choices (what we call the "fabric" of life) all play a role in how the arts speak truth and how that truth is received.

Is Fiction True?

Artists who "speak" the language of night understand that our fictional creations, music, and performances are just as reliable in telling the deeper truths of existence, as day language is in conveying demonstrable fact.

. . . <u>as reliable</u> <u>as day language:</u>

It would be wrong for us "artist types" to denigrate the contribution to modern life of historians (those bankers of tradition), mathematicians, scientists, techies, et al. What if everyone on earth were like us? Yikes! Spare us!

Imagine a world without science. Without statistics, for example, we wouldn't know—*horrors!*—who the American League batting champion is or

who won an election and by what margin.

I've written and published several novels. Are they good, well-written stories? Liking or not liking a novel is subjective, but most of my readers think they're entertaining and somewhat enlightening.

But are my fabricated stories *true*? Hmm. That depends. I am often asked: "Are they the story of your own personal life?" or "Is the main male character you?" The existential answer to both is no. But, is there a sense in which my stories are my life in disguise? Of course. Anyone who knows me intimately and has shared the major events and twists and turns of my life will recognize pieces and parts of me in every story. But, those seeds are widely scattered across a range of characters — including the villains.

The same can be said of every art form. Concert violinists inscribe their signature in vanishing ink on every piece performed. No two renderings by the same fine artist are identical. A hundred sopranos can bring to life the role of Mimi in Giacomo Puccini's opera, *La Boheme*, but no two are exact copies of the consumptive young woman

who dies tragically, leaving her weeping lover Rodolpho a total basket case (though still in excellent voice).

Must the Artist Be Worthy Of Creator-Spirit's Gift?

Simple answer—none of us are worthy! History testifies that the Spirit bestows artistic talent indiscriminately, without a litmus test for personal merit. Talent is unearned and undeserved, otherwise why would we speak of it as a "gift."

> *Imperfect people are all God has ever had to work with. That must be terribly frustrating But [God] deals with it. So should we!*
>
> Jeffrey Roy Holland

Dealing With It

How do we as individual artists deal with our character flaws and moral wrongdoings? An answer might be found in the wonderful Serenity Prayer composed by Reinhold

Niebuhr (1892-1971) and used extensively by recovering addicts.

> *God grant me the serenity to accept the things I cannot change; courage to change the things I can; and wisdom to know the difference.*
>
> *Living one day at a time; enjoying one moment at a time; accepting hardships as the pathway to peace; taking, as He did, this sinful world as it is, not as I would have it; trusting that He will make all things right if I surrender to His Will; that I may be reasonably happy in this life and supremely happy with Him forever in the next. Amen.*

This short prayer has brought peace of mind millions of flawed people. Also to a host of reforming Type A personalities. It should also be on the lips and in the heart of every impatient, perfection-seeking artist.

Will I Lose My Gift, If I *Neglect* It?

If I don't hone my craft through study and practice . . . if I don't put in the work my gift requires to lift me to the highest level of my potential . . . if I let self-doubt, introversion and fear of failure silence my gift . . . I may not lose my gift entirely, but I may bury it so deep beneath the muck of my self-indulgence that I won't remember I ever had it.

The sad truth about bottling up (an apt choice of words when alcohol is the thief) my unique talent is that I might be letting down the whole Universe. After all, Creator-Spirit bestowed my gifts, not for my own personal benefit—although that is a blessed part of being gifted—but to offer in return all the beauty, joy, and inspiration I can during the span of my lifetime.

As artists, we may not lose our gifts through neglect, but we may still be guilty of not fulfilling the purpose of our existence, that is, to enhance others' quality of life.

> *Where there is undeveloped talent,*
> *there is unfulfilled destiny.*
>
> Gina Duke

What If I *Abuse* My Gift?

What might that mean here? It speaks to using (abusing) gifts and talents to feed the *dark side* of human nature, rather than appealing to what is best in our collective spirit.

History testifies that artists, who were or are imperfect in their own personal lives, have produced amazing masterpieces in every area of the arts.

My favorite author, Victor Hugo, is a good example. In the introduction to his 1999 biography of the great writer, Graham Robb paints a picture of a man whose life was so complex that whatever might be said of him would be true. He was indeed a man of contradictions. Those who knew him described Hugo as a(n):

- womanizer

- self-centered man, uncaring about others' well-being

- angelic child prodigy

- militant monarchist

- revolutionary socialist

- defender of the downtrodden (*les miserables*)

- repressor of revolts

- instigator of riots

Could Hugo—or *anyone*—have really been all those things? It seems so. I have run across people like this in my life. A few examples leap to mind, where they had best remain.

Speaking of Victor Hugo, I have a board devoted to his wisdom on my Pinterest page. I'm blown away sometimes by his depth of wisdom. At the same time, I'm aware that Adèle Foucher (d. 1868)—Hugo's wife—might have had a different opinion. She was no paragon of virtue herself. Around 1831, Adele became romantically involved with a literary critic and good friend of Victor's named Sainte-Beuve. Around this same time, Victor became enamored with actress Juliette Drouet, who soon became his mistress. Oh well. I guess it's true that my literary hero was a man of contradictions.

Do drugs, alcohol abuse, and other vices enhance the artistic gift? That's a hard question to answer. Would Ernest Hemingway and others have been better writers, musicians, composers, etc., if they had been "straight arrow" folks? Honestly, I don't

know the answer, but the question intrigues me. It coaxes me to deeper exploration.

Pushing Frontiers

Artists—at all points along the scale of talent, proficiency, maturity, sobriety, sanity—push creativity as far as their gifts and desires will take them. In the process, they risk crossing the boundaries of traditional social and religious values, both in their work and sometimes their personal lives.

Christian Wiman offers this insight:

> *Artistic inspiration is sometimes an act of grace, though by no means always.*

I believe Creator-Spirit has great compassion for writers, poets, actors, singers, musicians, painters, and sculptors, et al. and must give them lots of moral leeway. They give so much of themselves for the entertainment, inspiration, and social education of their audiences. All who put their

work out there for the rest of us to scrutinize and critique do so at great risk. Yes, some are fortunate enough to reap a financial return on that investment and the fame that goes with it. In exchange, they put themselves at the mercy of the public and the media.

What if someone in the arts uses innate talent to negate Creator-Spirit's desire to show compassion and lift humanity to a place of mercy and respect for all people?

I also believe that Creator-Spirit loves *all* artists! Even those who engage in their art for less-than-honorable reasons!

Moment of Truth

 When our life is over, Creator-Spirit will say to those who ply their divinely given talents, "Come, account for your gifts. Show me what you've done with what I gave you . . . when I kissed you and sent you off into the world."

Each of us must have a ready answer to this all-important question: *What do I have to show for the talents I've been given?*

Before moving on to Part III, I AM, take some time to reflect on the following questions.

How do I express <u>truth</u> through my art?

What am I doing to nurture and grow my gift?

How might I be neglecting or even damaging my gift?

What will I have to say for myself, when I finally meet Creator-Spirit to give an accounting of the fruits of my gift?

Part III

I Am . . .

Silence in the Artist's Life

Before sharing any gift externally with others, an artist needs to plunge into the creative well of silence. As the book of Ecclesiastes says in Chapter 3:

> *There is a time for silence and a time not to be silent.*

Silence is uncomfortable for those of us living in bustling societies that place primary value on action, output—performance. Those of us in the arts can feel guilty about the apparent inaction of "doing nothing" in our silence. It's essential for us to understand the creative process in its entirety. Before we can produce any work of art in any genre, we first need to withdraw from activity and bore deep inside ourselves. One there, we need to allow ourselves a period of *seeming* inactivity.

What really happens in the silence of the artist's soul is a lot of "activity" in the form of imagination, inspiration, observation, and preparation. In the process, artists discover their own one-of-a-kind Self that is like no other in all the universe, past or to come.

Imagination—The Latin word *imago* (image) is the root word for picturing for ourselves (imagining) what Creator-Spirit might be calling us to bring forth from the silent well of our creative gift(s).

Inspiration—In the silence, we listen for seminal concepts that may grow into nagging thoughts and grow into "Wow" moments. What arises next is exhilarating excitement followed by a pressing urge to express whatever "product" divinity is calling us to gestate and give physical life to.

Observation—Seeded by imagination and aroused by inspiration, we find ourselves moved to open our eyes to observe everything and anything around us in the universe that will become the "flesh and blood" of our work.

Preparation—Then comes the lengthiest portion of our silence: solitary honing of the skills that will enable us to create a work that is the fruit of

imagination, inspiration, and observation. Composer's write notes in sharps and flats that become raw material awaiting rendition through other artists' gifts. Lyricists snatch fragments of words and phrases born in their silent musing. They companion them with their own or another composer's music. Singers take lessons and learn how to turn those notes and lyrics into unique renditions of prior creations. Actors study to hone their dramatic skills and spend hours memorizing lines, again to give their unique expression to the playwright's story. The same for every genre of art.

Rather than fear or shun silence, a true artist understands that quality work depends on the hours, days, and years it took to bring what started as a seed to full-blossomed fruition.

Pointing to the Moon

> *God created humans in God's image; in the image of God the Lord created them; male and female.*
>
> Genesis 1:27

Creator-Spirit splashes night language gifts like a shower of stars across the universe. Roman Catholics have a generic word for this kind of universal generosity. That word is *"sacrament"* — meaning a *visible sign* of the close-up, personal presence of our invisible Creator-Spirit.

As usual, Rumi had an insightful saying: the finger that points to the moon is not the moon. It's just a finger, but it plays an important directional role. It guides our vision to the object at which it points. Lest we i-n-f-l-a-t-e our stature in the creative universe, we need to distinguish our "pointer" role from Creator-Spirit's. One is the originator and final objective of all artistic gifts and works. We are stewards of those gifts.

By the lives the Hebrew prophets lived and the visions they experienced, they served as Yahweh's signposts to guide travelers along the journey of lifelong fidelity. Failing to listen to a proven prophet—as opposed to the charlatans abounding in Israel—was to sign the nation's death warrant.

Take Ezekiel for example. In Chapter 12, Verses 1-12, Yahweh tells the prophet to dress up as one being shipped off for exile by a conqueror (the sign/symbol). Then, wearing this "costume," he

was to show himself to his rebellious fellow religionists:

> Say, "I am a sign for you," for what I have done will happen to them. They will be deported, exiled.

And they were!

Yes, in both dress and words, Ezekiel was a human "finger" pointing to the compassionate God of Israel, whom the people had spurned. Yahweh was trying one more time—not successfully—to save the ancient Israelites from their own stupidity.

Artists and the works we create / perform are, like Ezekiel of old, signs (sacraments) of that same compassionate presence in our world today.

The Call To Be Humble

In its most accurate sense, humility is a synonym for *truth*. Too often, people confuse humility with a form of falsehood that seeks to self-diminish

talent. For example, it might go like this, after receiving a compliment for a good performance:

> "*You sang beautifully tonight.*"
>
> "Oh, *it was okay, I guess. I wasn't at my best*" (when the artist knows she "knocked it out of the park").
>
> A truly humble response would be a simple:
>
> "*Thank you. I'm so pleased you came.*"

That kind of humility accepts the truth that we are *tiny*, but *important* pointers to the mystery of Creator–Spirit's close interaction with the human race. What this means is that each of us is a conduit, a connecting link between Creator-Spirit and our audiences. *Conduit* can be defined as a *dynamic of connection*. A T.V. station is metaphorically called a channel.

Channeling

Sharing our gifts is a "channeling" process. We are small-'c' creators. We produce from within our-

selves the material, vocal, written, musical pointers that reveal something about the Spirit's love and compassion for humanity.

We are dynamic conduits of Creator-Spirit's desire for relationship with everyone who formerly lived on this planet, all who walk on it today, and all those destined to occupy it in the future. The website, ask-angels.com, defines channeling in this way:

> *Channeling is allowing love from the higher realms to flow through you.*

Singer, poet, and mystic Francis of Assisi (1181-1226) understood this truth well. Francis saw his life's mission as "channeling" Creator-Spirit's peace, love, and pardon to the world:

> *Make me a channel of your peace.*
> *Where there is hatred let me bring your love. Where there is injury, your pardon, Lord--and where there's doubt, true faith in you.*

For Francis, all of creation—living and inanimate—points to (is a sacrament of) our loving Creator-Spirit.

"Canticle of the Sun"

Be praised, my Lord, through all your creatures, especially through my lord Brother Sun, who brings the day; and you give light through him....

Of you, Most High, he bears the likeness.

Most High, be praised through... Sister Moon and Stars... Brothers Wind and Air ... Sister Water... Brother Fire... Sister Mother Earth...

Those who forgive for love of you, those who endure sickness and trial...

Sister Bodily Death... praise and bless my Lord, and give thanks, and serve him with great humility.

(translated by Bill Barrett from the Umbrian text of the Assisi codex; abridged)

Francis isn't talking about some "voodoo" kind of channeling, but rather a call for people in the arts to consciously acknowledge the . . .

- *reality* of our gift

- its divine *source*

- *our role* in the ongoing creative process

- our service to *others* (the artist's purpose in life)

> *Your deeds may be the only sermon some persons hear today.*
>
> Francis of Assisi

Playing off Francis's words, every artist can say without exaggeration:

> MY ART *may be the only sermon someone hears today.*

A Personal Example

Most important in the creative process is for us to be "intentional" artists: fully aware of what's truly going on when we are creating/performing.

I do a lot of public speaking, primarily within the context of my role as lay minister at a large suburban parish in Northern California. Before each class, homily, and workshop, I spend some quiet time, during which I gather my thoughts and pray:

> "Lord, let me speak well of <u>you</u>. Let my thoughts be <u>your</u> thoughts, my words <u>yours</u>."

In other words, I do my best to remove the focus from myself. I pay homage to the source of whatever talent I have received.

Another essential ingredient of the wisdom of the artist is brutal clarity about gifts we do not have.

I have two very talented sisters, one older, one younger. My older sister, now retired, had an amazing operatic voice. A pure-toned and expertly

trained coloratura soprano, Natalie sang the lead role of Santuzza in the Santa Monica (CA) Opera Company's production of Pietro Mascagni's *Cavalleria Rusticana* at the age of 13! Over a forty-plus year career, she performed nearly every major coloratura role in the operatic repertoire. But, Natalie played no other instrument. She knew her gift and spent her life perfecting her craft.

My younger sister, Toni, acted and sang in local theater productions in and around the greater Los Angeles Area. She also did some television work. Toni could not do what her sister did, but it never bothered her. She knew her gifts and enjoyed displaying them for audiences.

How I've wished I could sing, play the piano, act on stage, but I had no talent in these areas. I took guitar lessons for a while, but never advanced beyond the string equivalent of "Twinkle, Twinkle, Little Star." I did have some experience in film as a child, but my career was short and the roles I played required not an ounce of dramatic giftedness.

When Natalie and I were children, our dad enrolled us with Central Casting in Hollywood. Natalie

managed to get a "speaking part" in *The Hunchback of Notre Dame*. At the scary height of the action, she was part of a terrified mob running through the streets of "Paris" screaming, "The hunchback is coming! The hunchback is coming!"

I landed a few roles in films, whose scripts called for "Italian-looking kids." My only known on-screen appearance was in *Butch Minds the Baby*, starring Virginia Bruce, Broderick Crawford, Dick Foran, and Fuzzy Knight. I'm really dating myself now. I have a (probably pirated) DVD of the film in my possession for proof. None of my on-screen or off-screen assignments (I was a stand-in for a famous child actor) required an ounce of talent.

Not until midlife did I discover and trust that I did, in fact, have some artistic talent, a measure of genuine giftedness. I can write publishable fiction, nonfiction, and poetry. Who would have guessed?

I surrendered any thought of becoming a writer when my sophomore English teacher read aloud one of my class-assigned dramatic short stories. He couldn't—or wouldn't—stop laughing as he read it to all the class. Then, he panned my work with such mocking humor that everyone—except yours truly—just about fell out of their desks. I vowed on the spot never to try my hand at fiction again. I

would not put myself in that vulnerable position again—ever.

Since rediscovering and trusting my literary voice, I have published seven novels (four commercially and three independently). I finally decided in my forties to show that Tenth Grade teacher how wrong he had been to squelch my budding talent. It wasn't that my teenage story was all that great.

He just went too far in ridiculing this timid aspirant's sincere effort. I was too immature at the time to admit that the story was weak, while still trusting my talent and desire to share my work with the world.

There must be a moral to this story, but I haven't found one. The very retelling of it colors my cheeks.

Everyone In the Arts Is Gifted

We can say in truth that all those who see and define themselves as artists—amateur or professional, famous or unknown, beginner or lifer—have arrived at a moment in life, when they

recognized within themselves some degree of giftedness. And that recognition changed both their self-image and their lives. Every artist lays claim in some way to this spiritual phenomenon described by Oprah Winfrey:

> *There is a vision for my life that is greater than my imagination can hold.*

Are all artists equally gifted? The simple answer is, "No." In reality, though, the truth is subjective and largely dependent on personal taste.

So, what is the great "I AM..." of our creative lives and mission?

- I am a composer; I cast my net in the universe to snare the unheard music of the night.

- I am a singer; I give my unique expression to the composer's song.

- I am a musician; I add life and passion to notes, flats, and sharps.

- I am a dancer; I channel divinity through my body.

- I am an artist; I interpret divine beauty and truth.

- I am an actor; I give flesh to the written word.

- I am a writer; I tell the stories of the Universe in human words.

- I am a poet; my verses sing the melodies of language to move and inspire the soul.

- I am a playwright; I scour heaven & earth for the deeper truths of existence.

Reflection

Spend some private time reflecting on your personal "I am." Who am I as an artist?

The Soul of Art

I am __(*my creative gift*)__;

Part IV

Sharing Our Gifts

Ars Gratia Artis

Ars gratia artis, the motto of Metro-Goldwyn-Mayer Studios, is Latin for "art for art's sake." It declares art's independence from outside intervention.

The phrase, *"L'art pour l'art,"* is credited to Théophile Gautier (1811–1872), who seems to have been the first to apply the phrase as a slogan for the arts in general. Gautier was not the first to write those words. They also appear in the works of French philosopher Victor Cousin (1792-1867), French-Swiss novelist and political activist Benjamin Constant (1767-1830), and American poet, essayist and short story writer Edgar Allan Poe (1809 – 1849).

In his essay, "The Poetic Principle," Poe argued that:

> *We have taken it into our heads that to write a poem simply for the poem's sake . . . and to acknowledge such to have been our design, would be to confess ourselves radically wanting in the true poetic dignity and force: but the simple fact is that would*

> we but permit ourselves to look into our own souls we should immediately there discover that under the sun there neither exists nor can exist any work more thoroughly dignified, more supremely noble, than this very poem, this poem per se, this poem which is a poem and nothing more, this poem written solely for the poem's sake.

The Gift of Art

Does the validity of *"L'art pour l'art"* rule out the possibility of a higher purpose for the arts than the beauty and meaning of the work itself? Let's see.

The main theme of this book is to acknowledge art as a Spirit-driven mission and vocation. A native (inborn) ability to create/perform works of art is given for the elevated purpose of:

- *development*

All of us in the arts need to hone our craft through dedicated study, rehearsal, repetition, practice— even when we don't feel like doing it and especially when we think we've maxed out our

potential. How can any of us know that we do not have one more, or multiple, works within us that may exceed anything we have yet produced?

Am I too old to keep going? Too sick? Or just too wearied by past failures? Am I too challenged by my physical condition to keep on keeping on? In answer to this last question, I offer the example of Stephen Hawking. He received a diagnosis of motor neurone disease (a form of ALS) in 1961, at the age of 21. Undaunted, he has gone on to publish one major science book after another over the past four-plus decades.

Conquering inertia demands a commitment to learning our craft in special academies, classes, workshops, critique groups, and through participation in professional organizations.

After becoming proficient in our chosen craft, we do not become true artists, unless we seek opportunities to make the product of our effort available to others. A singer taking voice lessons needs to find opportunities to perform—in shows, choirs, solo, etc., wherever desire and opportunity lead. The same for painters, sculptors and actors— whatever our artistic gift might be.

I've had conversations with "wannabe" published authors (usually shy fiction writers), who claimed to have finished multiple novels. I always ask, "Have you submitted your work for publication? Or published independently" I'm bewildered when these closet authors confess that the completed manuscripts are sitting on their bookshelves or residing on their computer.

- *sharing*

Artists channel Creator-Spirit's beauty, compassion, and love. Our mission and call is to bring *some*-thing into being where before there was *no*-thing.

Our ultimate gift is that, like Creator-Spirit, we do not hoard our transcendent experience and its fruits. Art is our "voice." We cannot, we must not, remain silent. If we engage in the arts merely for our own gratification, we risk forfeiting our claim to be artists. Recall that art, like love, requires that it be given away.

In *Les Miserables,* Victor Hugo expresses this conviction in reference to composers and musicians:

> *Music expresses that which cannot be put into words and cannot remain silent.*

"Cannot be put into words and cannot remain silent." What a perfect depiction of the artist's grand dilemma . . . and great challenge! We dare not remain silent. Irish singer, songwriter, musician and producer Enya Patricia Brennan, best known simply as Enya, echoes Hugo's conviction in her hauntingly beautiful "How Can I Keep From Singing."

> *No storm can shake my inmost calm,*
> *While to that rock I'm clinging.*
> *Since love is lord of heaven and earth,*
> *How can I keep from singing?*

In sharing our art, we are none the worse off for it. Just the opposite. Giving enriches both society and the artist. In the words of young mystic and World War II martyr Anne Frank:

> *No one has ever become poor by giving.*

Our talent is God's gift to us. What we do with it is our gift back to God. No artist can take sole credit for the gift of talent. It's not of our making. It's good to be rightfully proud of our abilities, as long

as we are humble enough to admit we are not their source.

> *I am a humble artist molding my earthly clod, adding my labor to nature's, simply assisting God. Not that my labor is needed, yet somehow I understand, my Maker has deemed it that I too should have unmolded clay in my hand.*
>
> <div align="right">Piet Hein</div>

Justifiable pride . . . truthful humility. With that mindset, we can enjoy our gifts and even enjoy the work it takes to grow our art through training practice, and study.

Our gift is given for us to lift ourselves and others beyond the routines and limitations of *"day-language"* life. We create wings that enable imagination to soar. A true artistic gift is a volcano deep within us, a compulsion seeking—*demanding*—outlet.

> *Art is a human activity having for its purpose the transmission to others of the highest and best feelings to which men [and women] have arisen.*
>
> <div align="right">Leo Tolstoy</div>

Created for beauty, artists cannot truly live without channeling Creator-Spirit. It's who we are at the deepest level of our being. Only in sharing our gifts do we fulfill our highest purpose and mission.

Does Sharing Require an Artist To Perform in Public?

No, there are other ways that creative people share gifts and talents:

- teaching
- directing a chorale or a church
- facilitating others' expression of their art through
 — agenting other artists

 — publishing their works

 — filmmaking

 — directing performers on stage, screen, and television

— supporting the arts by enabling artists to share their work

— choreographing for dance

(add to this list)

— _____

My dear friend Carol Larkin, of Oakland, California, is an accomplished fine artist, sculptor, and a retired high school art teacher. She now devotes her talent to gardening. In a recent conversation she opened my eyes to this new expression of her artistic giftedness:

> *My creativity gets put into my garden, which always needs attention and love. I don't mind because pruning trees and bushes is like sculpting. I enter into the aesthetic quality of the act. It is quite engaging and touches my soul in a very deep way. I seem to be able to connect with the life force in the plants and the dirt.*

Do Artists "Speak in Tongues"?

Hmm? Let's see . . .

On the first Pentecost Sunday, Jesus' disciples went into the streets and began proclaiming the good news of his "Way" of life.

Those who listened were amazed and puzzled by one phenomenon in particular, which I paraphrase here:

> *We're from all over the world, and our Hebrew isn't very good, but when these people speak, we hear them in our own mother tongues.*
>
> Acts of the Apostles 2:11

Isn't that exactly our experience as artists? We "speak" the language of our particular gift, but audiences "experience" it in their own inner language ("mother tongue").

Applying this to writers, for example, people may read the same book, but they do *not* read the SAME book.

Many people attend the same dramatic performance, but they do *not* experience the SAME play.

People listen to the same music, but they do *not* hear the SAME song.

There's a Latin expression: "*De gustibus non est disputandum.*" Translated: "*You can't argue about personal tastes.*" We all filter works of art through our own life experience, temperament, spirituality, or philosophy of life. That's both the joy and the risk that we artists take in doing our thing and sharing our gifts in the public arena.

How do we react to negative criticism and reviews? For example, what if my book, film, or performance gets 2 stars, not 5? How much weight do I give to these negative reviews?

Here's a personal confession. I tend to give negative reviewers more weight than I do to those who love my work. Maybe it's my Italian ancestry, but I hear that inner voice whispering: "*Those who praise your work are just being nice.*" Or, try this version: "*The dissenters are a lot smarter than the rest of them.*"

Three Little Words

Every artist needs to treasure three key words or concepts:

> REMEMBER
>
> CELEBRATE
>
> BELIEVE

We REMEMBER that "only the artist can see in the dark."

- We are society's imaginers, its dreamers, personally appointed to that role by Creator-Spirit. What a vital service to humanity! The better our work, the better our society, because we help lift our audiences out of the routine of their often humdrum existences. We have the ability to raise them to the realm of the spirit, whatever that might mean in the life of each individual.

- We need to remember what our role is in the creative process. Don't ever forget that we are channels of the divine, fingers pointing heavenward. We are not the source of our gifts. We are individual points of light among the billions of stars that Creator-Spirit has splashed across multiple universes.

- It's essential for us to remember the day dreams and night dreams that launched us on this voyage and the work we have done and the promises we made to ourselves—and perhaps to others.

- We need to remember well what it is that we see (imagine). We are the eyes of society and often—if we are doing it right—its voice. With that comes the responsibility to report through our art what is best in human nature and call our audiences to discover what is best within themselves. If our "seeing" and "remembering" are flawed, we risk abusing our gifts. The results for our community, our world and ourselves can be devastating. Yes, we have that negative potential. Creator-Spirit freely took that risk when entrusting us with pieces of the divine.

We CELEBRATE

Remembering ("mindfulness") makes *true* celebration possible. As artists, we celebrate the privilege of co-birthing with Creator-Spirit and sharing our gifts with a world in dire need of reasons to celebrate life.

Artists have a reputation for suffering in their life and work, as if the product would be tainted if it didn't result from emotional agony and angst—from a reckless plunge into a lifestyle of narcissism, alcohol, or drugs.

What many artists have yet to learn—and many never learn—is the sheer *JOY* of art. Yes, of course, the road to great art is necessarily marked by endless labor, hours and days spent alone at the writer's desk, the artist's palette, the dancer's barre, the actor's rehearsal hall, etc. But, there also needs to be sense of joy at *every* stage of the journey.

We remember, we celebrate . . .

We BELIEVE

> *It has been said that faith is a certain widening of the imagination.*
>
> Lucy Hart, Poet

We believe that the source of our gift is the one who bestows upon us that "primal kiss" spoken of earlier.

Our role is to elevate audiences to see beyond the outward material of our chosen art form (words, dance, music, painting, acting, etc.) to the wonder of Creator-Spirit, who uses and encourages our imperfect selves to beautify and raise up our world.

The joy this kind of celebration brings to us and others makes us want to . . .

REMEMBER more clearly,

CELEBRATE more enthusiastically,

BELIEVE more deeply.

This endless loop feeds artists throughout their careers, to the end of their lives . . . and into the next.

So, Then, Who AM I . . . ?

I am the fine and graphic ARTIST; I paint, sculpt, draw to touch the hearts of those who view my work.

I am the COMPOSER; I transmit Creator-Spirit's beauty and compassion through the gift of music.

I am the MUSICIAN; I channel the composer's vision to bring joy, uplifting peoples' spirits.

I am the SINGER; I add voice to music, moving and entertaining my audience.

I am the DANCER; people's spirits soar along with my body.

I am the WRITER; I use language to transport my readers.

I am the POET; my verse gives light and new life to soul-dead spirits.

I am the PLAYWRIGHT; I speak truth to challenge those who might be life-blind and indifferent.

I am the ACTOR; I hold a mirror to the world — and to myself.

Reflection

How do I relate the concept, "can't remain silent," to myself and my art?

How do I experience JOY in my artistic life?
How do I "celebrate" my gifts?

Afterword

Success, What Are You? And Where?

Up to now in this ode to art, I have avoided any discussion of the pursuit of commercial success. At the risk of committing cultural blasphemy, what the world calls success is not within the artist's *sole* power to attain. An artist in rabid pursuit of fame and fortune may fall into a long nightmare without hope of seeing the dawn. There can be no joy, no deep artistic satisfaction in this person's life, only one day of frenzied labor upon another.

Let me use the example of authors. That is the professional world I live in and with which I am most familiar. We dream of opening the book section of the *New York Times* and seeing our latest novel or nonfiction work on the coveted list of best sellers. Wouldn't it be great to adorn every subsequent book cover and promotional piece with that lofty label, "*New York Times* bestselling author"? You bet we would.

Let's be realistic. We've all read contemporary books that are beautifully written and truly satisfying, but did not make that list or receive any of the other prestigious literary awards. Which of us does not moan when a book we've just read and judged to be mediocre, at best, garners five-star reviews and gushing accolades?

What is our gut response, when genuine talent reaps its deserved reward? Is our first thought, "Why isn't that me? I work just as hard!" That kind of negativity does nothing to move us forward in our careers.

The moral is, we mustn't let life-stunting envy creep into our souls. We do ourselves and the world of art a greater service by letting the success of others spur us to hone our own craft with greater zeal. Let it motivate us to get up and out of our pity tents and enhance both our skills and marketing outreach in some positive way.

One way to do that is to immerse ourselves more actively in the local arts community related to our genre. I have been active in the Mount Diablo Branch of the California Writers Club for 20 years. I served two different terms as president and currently sit on the branch's board of directors.

Although I have written twelve books and three screenplays, commercial success has eluded me.

I am positive that, because of my involvement in the writing community, I am a much better writer today than I was in 1996, when I proudly gushed over my first (commercially) published novel, *A Love Forbidden*.

Month after month over the past two decades, I have gained inspiration from my writing community, my "homies." I applaud their successes, support them in their disappointments, and receive the same in return. I do all I can to be generous in sharing what I've learned. Above all, I encourage all my fellow writers to "keep on keepin' on."

To me, that's the definition of success in all the arts.

fin

Art & Soul
Workshops and Retreats

The author is available for 1- or 2-hour presentations, one-day or weekend workshops and retreats based on the content of this book.

The sessions offer guided reflection on the intimate relationship between artists and Creator-Spirit. Each session is designed for professional and aspiring actors, composers, dancers, fine artists, musicians, playwrights, fiction and nonfiction writers and poets, et al. Participants explore the source of their gifts and inspirations and the joy of sharing them. They are invited to REMEMBER the source of their gifts, CELEBRATE them, and BELIEVE in Creator-Spirit's call to make the world a better place through the ministry of art.

Contact
Alfred J. Garrotto at *algarrotto@comcast.net*
Facebook: *www.facebook.com/alfred.j.garrotto*
Blog: *wisdomoflesmiserables.blogspot.com*
Web: *www.alfredjgarrotto.com*

Nonfiction by Alfred J. Garrotto

The Wisdom of Les Miserables:
Lessons from the Heart of Jean Valjean

What can a 21st century seeker learn about life, love and spirituality from a 19th century French novel? Plenty. Alfred J. Garrotto offers Victor Hugo's flawed protagonist as a model for anyone in search of practical wisdom for everyday living. One of fiction's most beloved characters, the former convict and lifelong fugitive represents humanity in both its brokenness and its potential for selfless—even saintly—living.

Reflection topics range from forgiveness and the primacy of conscience to the joys and sorrows of parenthood. Each Reflection explores a universal theme, including the daily call to spiritual and moral conversion and the life lessons parents impart to their children. Questions at the end of each Reflection invite you to use the book as your personal wisdom journal.

Praise for *The Wisdom of Les Miserables*

"Alfred J. Garrotto incorporates the text of Victor Hugo's Les Miserables *and creates a workbook out of the lessons Jean Valjean taught through his life. I particularly admire the author's pithy answer to the truth of fiction."* — **Ron Hansen**. author of the bestselling novels, *Exiles, Atticus, Mariette in Ecstasy, The Assassination of Jesse James by the Coward Robert Ford, Nebraska,* and nonfiction works, including *A Stay Against Confusion: Essays on Faith and Fiction.*

"Alfred J. Garrotto has succeeded brilliantly in distilling the wisdom of a nineteenth century classic novel and using it to illuminate our twenty-first century lives. This part autobiography / part spiritual handbook seems to me a classic in its own right, one that stands on the shoulders of another classic." — **Tom Savignano,** Poet. *A Time To Ponder, A Time to Sing,* and *Prayers and Reminiscences*

Book **Sample**

PREFACE

Wisdom has suffered from short supply during the war-ravaged history of the past two centuries. That poverty continues into our own twenty-first century. This book is a plea for wisdom, not only in the public arena, which can seem beyond our meager influence, but at its very root in the life experience of ordinary men and women. If each of us can grow in wisdom—even a little—and manifest that growth in our daily attitudes and behaviors, we have power trigger a spiritual and moral revolution that will spread a balm of peace and harmony over our troubled world.

What is wisdom? In *Les Miserables*, Victor Hugo shuns an academic "wisdom is . . ." form of definition. In-stead, he reveals its qualities in the person of his main protagonist, Jean Valjean. The story begins with a spontaneous act of kindness done to the former convict by the self-effacing Charles Francois Bienvenu Myriel, Bishop of

Digne. In turn, Jean Valjean pays that gift forward in charity to the poor and fair wages to his workers. He risks his life to save another's and adopts as his own daughter Fantine's child, Cosette. He surrenders to the law, rather than allow an innocent man to be imprisoned in his place. He forgives and spares his lifelong pursuer, Inspector Javert. Often, he wrestles with God, Jacob-like, seeking escape from the demands of conscience, only to resolve in the end to do what is right and just.

Hugo understood the wretched consequences for marginalized people (*les miserables*) when societies fail to learn from past generations' mistakes. The author's interior life, fueled by faith in God and activism for social justice, gave his literary voice power to move readers' emotions and rethink their attitudes and opinions.

In Jean Valjean, Hugo provides a moral compass for principled living. He offers his readers hope that it is possible to exercise freedom of conscience, choosing right over wrong in a difficult, sometimes hostile social and political environment.

INTRODUCTION

The inspiration for this book came to me in the early 1990s, as I wept through the final scene of Boublil and Schonberg's musical version of Victor Hugo's novel, *Les Miserables*. From its darkened perch in the balcony of San Francisco's Curran Theater, my heart flew to the bedside of the dying Jean Valjean. Over the course of the evening, this fictional hero had moved me with his tale of conversion, forgiveness, and moral fidelity. I wanted to be at his side as he uttered these final words to his beloved daughter Cosette: "To love one another is to see the face of God."

That magical experience led me to read the unabridged novel for the first time and subsequently to deeper immersion in Hugo's text.

When the show returned for a repeat engagement a few years later, my wife and I saw it again, this time with our two elementary school-age daughters. I am not embarrassed to admit that tears flowed again from opening curtain to the final reprise of "Do You Hear the People Sing?" My own little Cosettes became enthralled with the story and the magnificent music—and have remained so into their adult lives. During the year

that followed, we wore out an original cast cassette by playing it to and from school every day.

A marvel of Hugo's story is its universal appeal. Set amid the political and social volatility of France during the first half of the nineteenth century, *Les Miserables* is still, in the words of author Mario Vargas Llosa, "one of the works that has been most influential in making so many men and women of all languages and cultures desire a more just, rational, and beautiful world than the one they live in."

I discovered in Jean Valjean the essential qualities of principled living. For one like me, a Christian who is always in process, Hugo's protagonist embodies the core values and ideals passed to me through my religious tradition. From this experience, I conceived a desire that grew into a passion. What if I could spend some time with Jean Valjean? What might I learn about life, love, and compassion for the poor from this former convict-turned-saint? What might I share of this gift with others?

I originally planned to identify and draw upon themes from the novel. I have done that. Then, I intended to create a series of philosophical-

theological essays based on those themes. I have not done that.

A new dynamic intervened along the way, and I followed the prompt of my creative instinct. Having meditated my way through the novel, I found it impossible to keep my own life experience at a safe distance from the work. Jean Valjean's journey from living death to redeemed life led me to review significant moments in my history. Like Hugo's protagonist, I have undergone a series of incarnations that have made me who I am today. Out of this examination has emerged, in part, an out-of-sequence memoir. Each new topic became an adventure in surprise that caused me, at different times, to shed tears of joy and cringe from memories long dormant.

While writing this book, I created a blog on which I posted early-draft samples of the reflections that appear on these pages. In response to one of them, international photographer and graphic designer Michele Roohani wrote with great wisdom and insight: "I read Hugo's masterpiece in French and Persian (my mother tongue) years ago. It's amazing how Hugo's book is relevant in my birth country, Iran. Cosette, Gavroche, Javert and even Eponine are known to millions of Iranians! Jean Valjean, a

hero. Humanity knows no country, no boundary, no color or religion."

From the beginning stages of this project, my goal has been to help the reader awaken memories, explore personal feelings, and gain insight through reflection on Victor Hugo's text. I hope you will identify with
my joy and pain, but move quickly to your own past and current experiences and their impact on your life journey. To that end, I have included an interactive element. A set of questions, under the heading, "Harvesting the Depth and Richness of My Life," follows each Reflection.

Ways To Use This Book

There are a number of possibilities for using this book for inspiration and personal growth.

Individuals have found it helpful to read a Reflection and spend time with the "Harvesting" questions.

The structure of the book is also well-suited for group discussion within small in-home or church-related journaling and sharing groups.

The Wisdom of Les Miserables is a valuable resource for leaders of human growth workshops and adult education programs. You will find ample material for the discussion of current issues related to individual morality (The Primacy of Conscience) and social justice (*les miserables*). The parenting sections (Shock and Awe of Parenthood and The Power of Story) invite discussion of family relationships.

However you use this book, I offer it to you as a gift, with a prayer that its message will lead you to deeper wisdom and provide nourishment for this portion of your journey.

www.ingramcontent.com/pod-product-compliance
Lightning Source LLC
Chambersburg PA
CBHW070252190526
45169CB00001B/384